PHASES OF A MUSE

Be the beautiful Muse of your own beautiful life!

PHASES OF A MUSE

❦

JANNA WATSON SMITS

Janna Watson

Smits

Janna Watson Smits

ISBN 978-0-578-72595-6
ISBN 978-0-578-72596-3

First Printing, 2020

For Mindy
my beloved sister
who stoked the warm embers
of my dream

Her.

Do you see it?

She carries it with boldness,

tenderness in her eyes.

Linger.

She holds everything there.

The whole of life can be seen

in her steady gaze...

held with understanding,

with humility,

with strength.

Pause.

Risk the safety of your thoughts

to fall into the imploring, dangerous beauty of hers.

Contents

I

the Dark

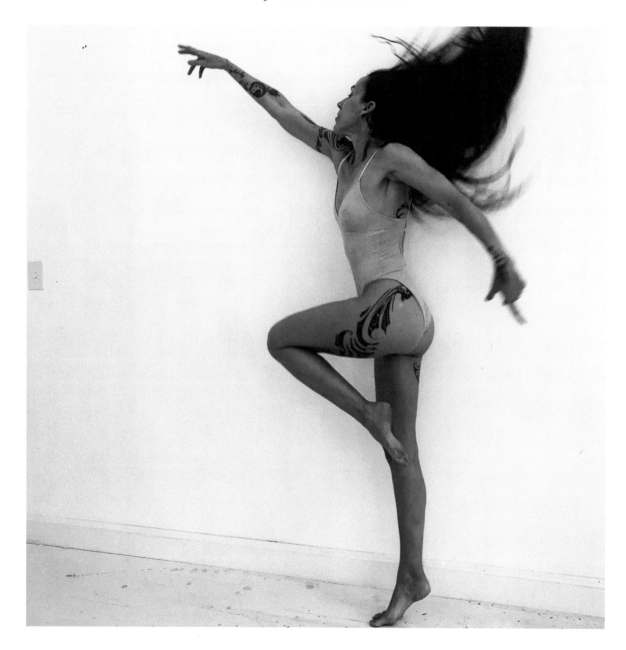

MY DANCE

No, I'm not dancing in the rain...

I'm standing in it
 looking up at the darkening sky
 and saying, 'do your worst.'

For I will not flee
I will remain

Drenched in what you shower down
 patiently waiting for the stillness
 that will follow

and then it's my turn...

to wage my storm
 which you fueled
 to view right now
 My Dance
 you thought I'd be doing
 in your story

but alas...I do not dance in rain
 unless I've composed the music...

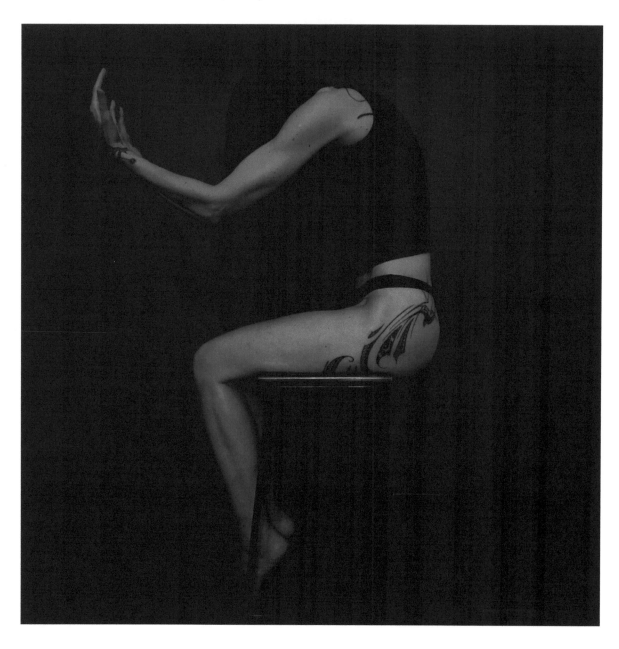

WAITING…REAPING

She stood in the presence of the rage
rooted
feeling the growing pressure
a balloon filled to its max…

 ready to burst

why did she desire to prick it?
knowing what the air held

unjust throat of words
steps to an open grave

why prick the pregnant air?

 Because she knows…
 she has forged a shield of favor
 a bow of precision
 built in the furnace of
 a life lived in the flow of the natural unfolding

 now prepared to match the power of the rage
 reaped from the years of waiting

 and she sees it…
 brave and true
 cruel and sure

this is what it looks like when you expose
a patient flower
to impulsive fury...

a vibrant rose
sheathed in a razor
dripping with the blood of second chances

rupturing with precision
 bestowing the justice
 bowing to the mercy and wrath
 imbedded deeply in her bones...
 the faithful devotion of one to the other

ensuring the balancing
even in their breaking

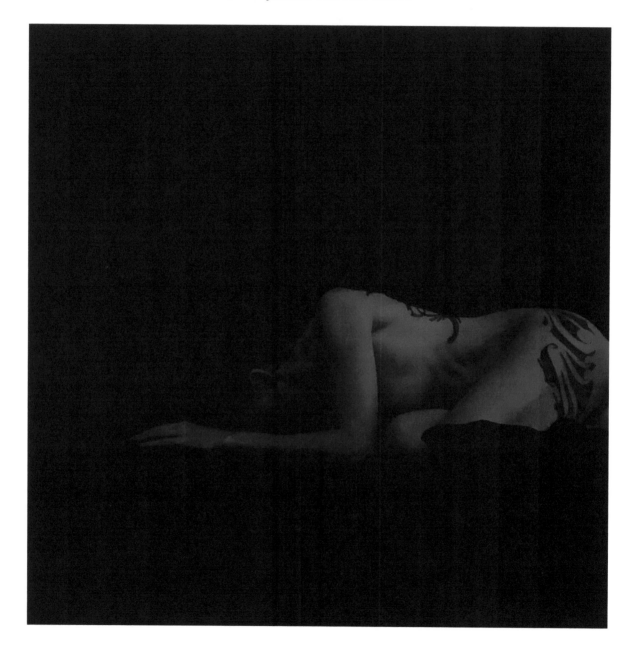

ASH

It stings

This is what I told them

But it wasn't the truth...

The truth is this...

> It crushes
> It suffocates
> It bleeds endlessly

The look, the venom, the words
both spoken and silent...
the body twisted in rage

It's the knife inserted into my belly
gazing with satisfaction

I hold it, calm it, cover it
hoping to contain it

You relax, you soften,
you breathe with relief

And for a moment
so do I

And then I look down
the knife still there,
my hand feeling
the warm oozing of my soul

Afraid to pull it from my flesh,
the poison a perceived dam
which would leave gaping wound
to bleed from

No, it does not sting

It incinerates

And the ash it leaves behind
becomes my cloak of less
waiting for the change
that will never come

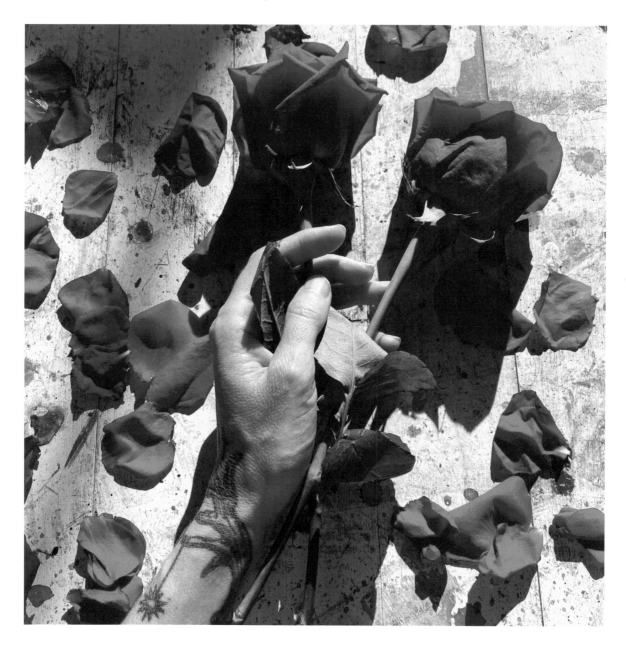

TWO FLOWERS

Two flowers
so beautiful and so strong
turn towards the splendid love
found in the other's arms

 roots travel deep
 sun and rain
 wind and storm...
 they are so lovely
 as they intertwine and form

Two flowers
shining faces
taking in the light
awaiting the sweet relief
of the deep restful night

and then it happens...
 slow at first
 but faster as it unfolds

roots no longer choosing to drink the elixir of this life
roots greedily choosing to siphon from the love of their life

Two flowers
losing petals
smiling as they do

roots strangling the other's...
 choking need through and through

Two flowers
bowing their heads
pulling life from the other

 forgoing the immanent grace
 turning from life's nourishing offer

Two flowers
the last petals fall
leaning into each other
desperate as they call

Two flowers
taking the other's last beautiful light
wilting and dying
lifeless in their plight

Two flowers
waiting...

to dance once more to the bitter music
within death's painful truth
that broken hearts bled dry can only hear
as they sway with their broken muse...

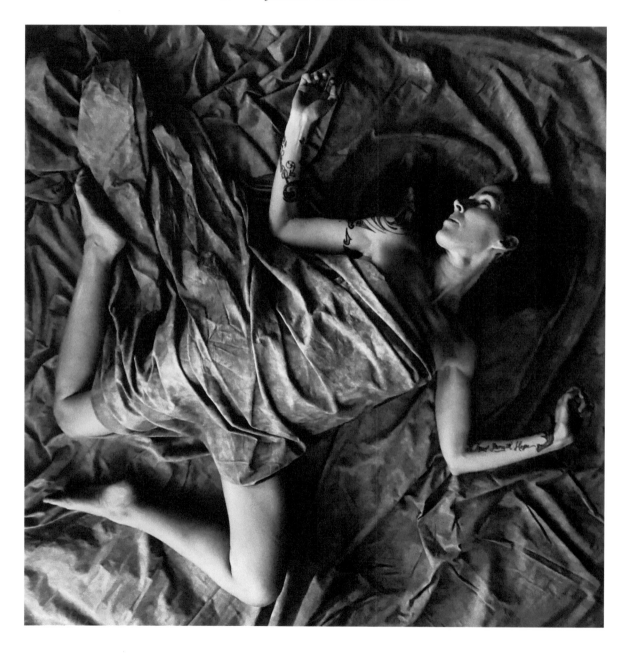

BURNING BLAZE

Her toes dipped in the black ink
fingertips in the golden pool
each fighting for the glorious win
each fighting for the right to rule

She, allowing the venom to seep
ooze & fill her pores
She, calling to the brightness
to quiet and calm the welcomed storm

Smiles freely given
as soft and pure as petals of a dying rose
Eyes of steely resolve
as sharp and merciless as a frigid winter morn

Her painting
vulnerable and innocent
exposing
ocean upon ocean of color

leaving he who falls into the spectrum
completely in love and fully dazed
falling further into her dense and darkened lines
revealing her friendship with the burning blaze...

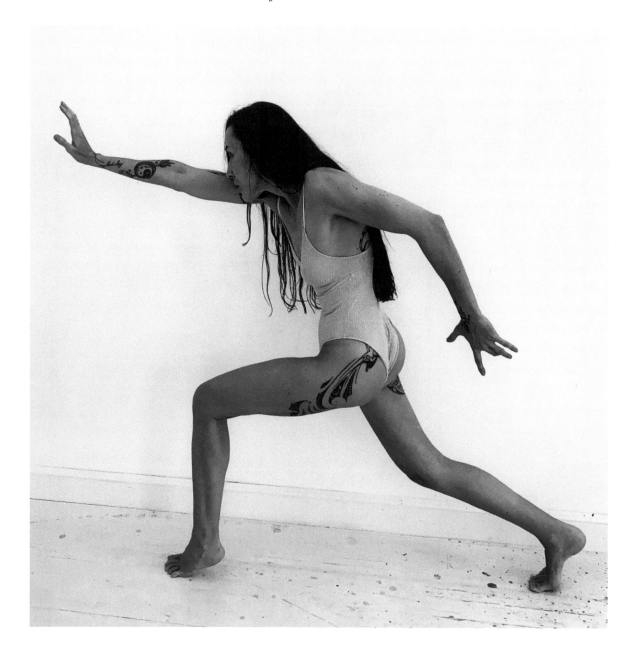

MISCALCULATED

You miscalculated

You thought your weapon
was stronger than mine

But you were so very wrong

Your sword of chaos
was never a match
for the knife of precision
forged within it

Your tongue of fear
was never as powerful
as the spirit of courage
born from it

Your narrow rule
could not compete
with the burning karma
sown through it

You saw a rival
easily conquered

But you miscalculated

I was a rival
 built
 from your chaos
 your tongue
 your rule

You thought your weapons
were fiercer than mine

But you miscalculated

You thought
You were playing to win...

When you were playing just to survive...

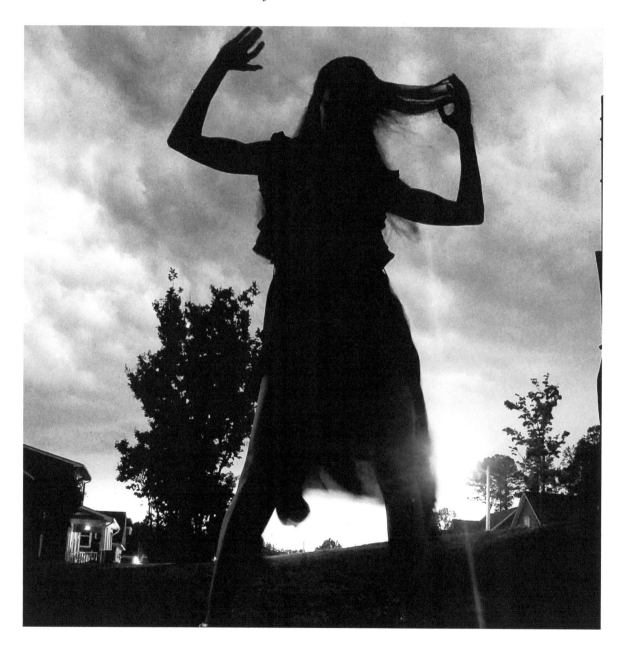

THE ONE

Shadow
you came for me
I lean closer, smelling the greed
as your dark weight
pulls at my long hair

And then I feel it...

My **Blood**
coursing through my being
pulsing
feeding the dark
feeding the fight inside of me

I rake my fingers
through my black strands
pulling at the shadow searching
for a **Soul** to call home

And my soul responds
with a silent voice
and **Deafening Certainty**

You won't find timidity here.
Don't you see what stands before you?
The One...whose game you just walked into,
whose scarred heart doesn't understand defeat

WARNING

I love when the rays of sunlight find her eyes
 she's my heaven on earth...

 then why do I crave the clouds
 that form so freely in them?

 it is because those eyes, my darling,
 are the ones that are your warning...

 do not wound a soul so full of heaven...
 for the paradise found in her will birth
 a warrior...

AND WARRIORS AREN'T WORRIED
ABOUT HEAVEN UNTIL AFTER
THEY'VE UNLEASHED THEIR HELL...

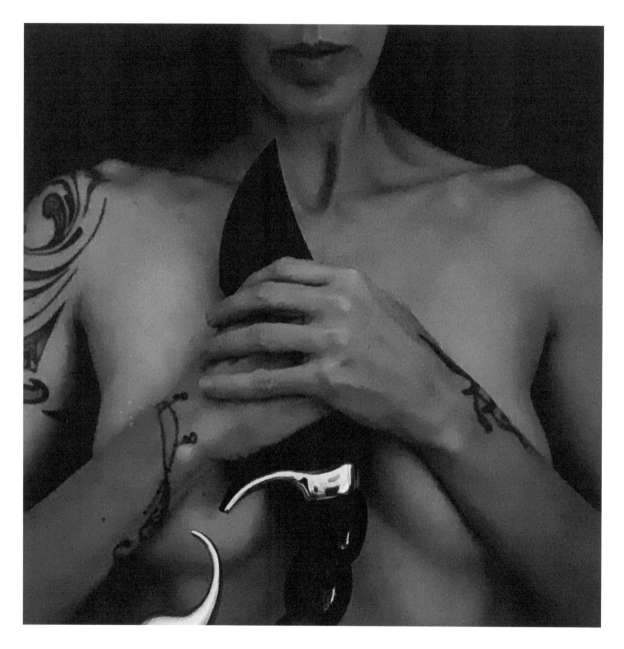

DAGGER

She would have never reached
for her dagger of vengeance
In the secrecy of night

If you had not
Pulled yours shamelessly
In the brightness of the light

II

the Gray

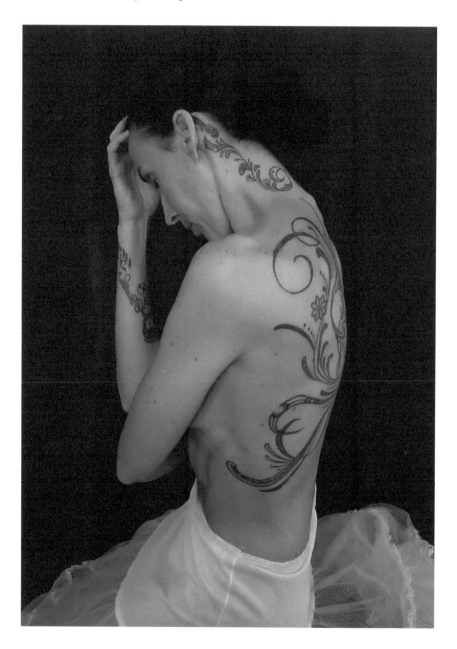

LET GO

It's here
right at the surface
just waiting to be spilled

let it fall
from its fragile place
tears wishing to be seen

it's ok
it really is
to feel this much inside

you don't have to know
where it came from
or where it will go

just let it fall
rising up from the deep
from where your spirit feels

it doesn't have to be beautiful
it just needs to be who you are

and who you are is so very much
sometimes it's hard to take it in

so let it out
let the world have it
give it what it gave

somehow, somewhere
this all makes sense

you don't have to wait
to understand every part
before you do or feel or grow

so let the welling up be released
let your skin feel what you hold inside

because somehow, somewhere
this all makes sense

so let the tidal wave and ride...

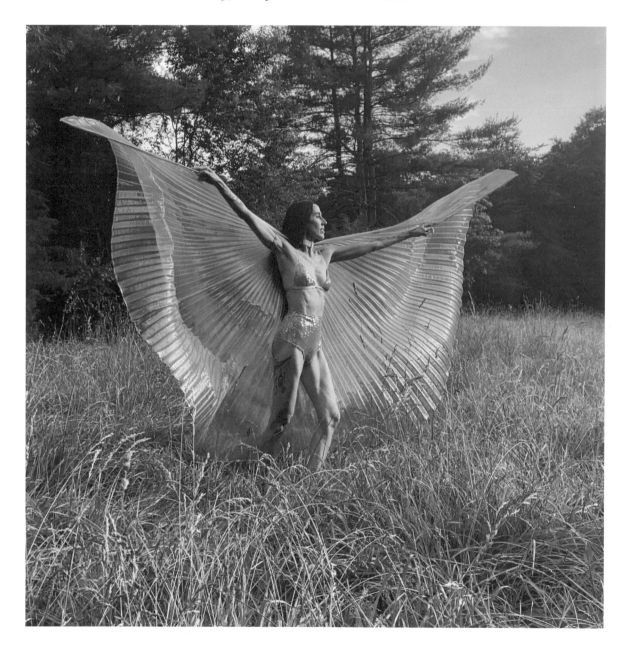

GLITTERING ASH

My beautiful butterfly
fluttering around my aching chest

you brought back to me
saving glorious breath

delicate wings
pastel petals
waiting to gently fall

transforming air
into sweet rescue
calming a powerful storm

seeing what was burning
standing, facing the flame

fragile yourself
fluttering resolutely
determined and unafraid

seeing the molten lava
breathing the suffocating smoke

finding a way
to turn glittering ash into gold...

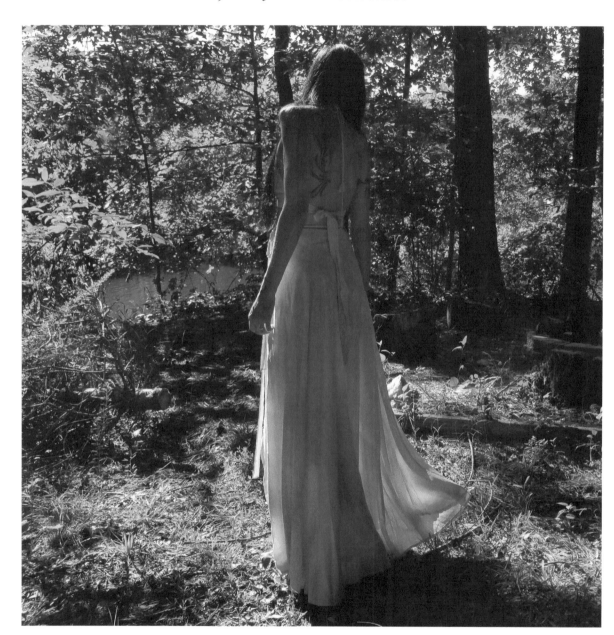

SHE KNEW

Sway with me
she said
and with a willingness he'd never known
he handed over his young heart

The drums beat loud
the whole of her
 overwhelming
 blinding
 disabling

You play your part
sheets speckled in blood
rays of burning light
reflecting in the red droplets

Did you know this was coming?
the spirit perpetually drawn to that which
leaves it exposed and vulnerable

She knew...

her brilliance
always a double edged sword
her presence slicing like a razor
as you soak in her stunning soul
your blood freely watering the ground she walks

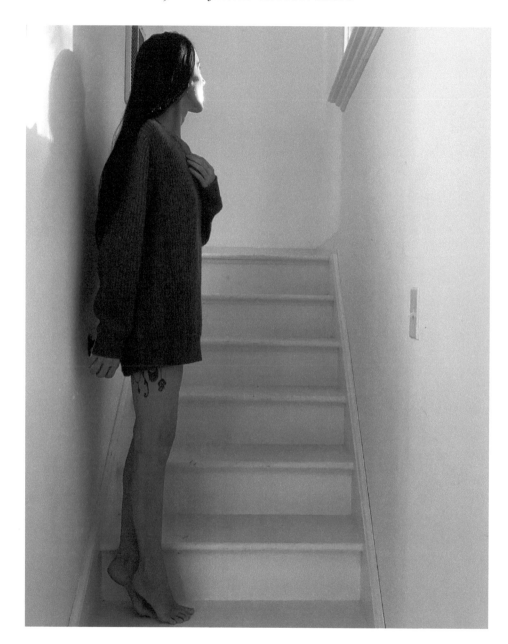

NEVER LET GO

I'm so glad I still have you
so glad I didn't let you go

you've been around so many years
should I have given you away?
passed you on to another
allowing us to experience life another way?

the years have worn you threadbare
your touch not quite as warm
but you've seen all I've been through
my victories and sad defeats
you knew my sister and my father
before they were deceased

...and I think that all means something
the witnessing of all that I am

and with all the bright wondrous things
that have lain before my feet
you're still the one I reach for
worn, familiar, true and keen

offering battered clothing off your broken back
you loyally choose to hang around over and over again

you're not as sure as you were
once upon a time
but you still find a way to cloak me
and touch my lovely life

in a closet, with all my others
that hang across from yours
you are more than just my favorite
you wear with proof, the one who never fled,
during the height of the storm

THE SHIMMERING GRAY

She never wanted a pedestal
never wanted a throne
she wanted what we all want...
she wanted to feel home

and she wanted connection
on the road we ultimately travel alone

She wanted understanding
within the judgement of failures she cannot undo
celebration within the moments of victory
when she shone so bright and true

She wanted what we all want...
acceptance of who she is
peace in the letting go
when something finally ends

She wanted to be remembered
for her beautiful dazzling light
but sometimes most of all
she wanted to be remembered for her darkest night

for her darkest acts hold equal claim
to all of the goodness that she is
for only within the grasp of darkness
could her magnificent light emerge, shine and live

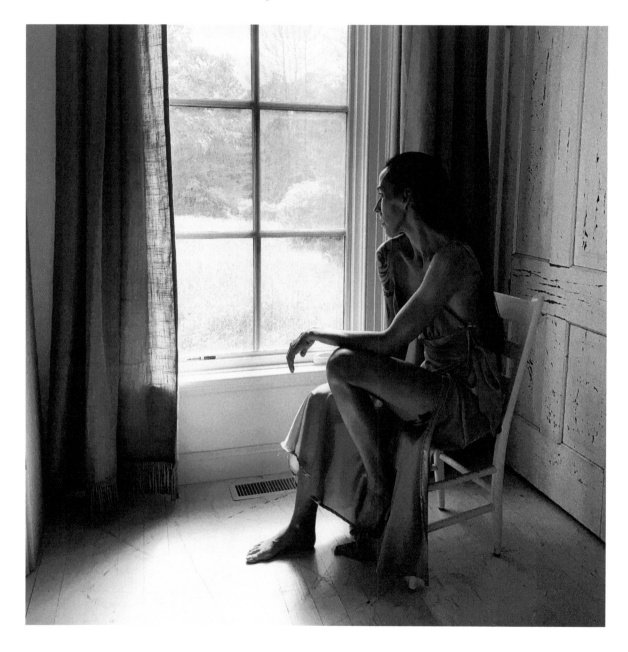

PRESSURE & TIME

he saw her
sitting alone
staring off into the distance

and with flawed assumptions
he knocked on the world
she seemed lost in

and then she looked at him...

and at once
he realized his mistake

he had presumed
her chosen solitude
was born from loneliness

but what he saw in her eyes
was a *force of nature*

a woman whose chosen solitude
was born from strength...

forged through *pressure & time...*

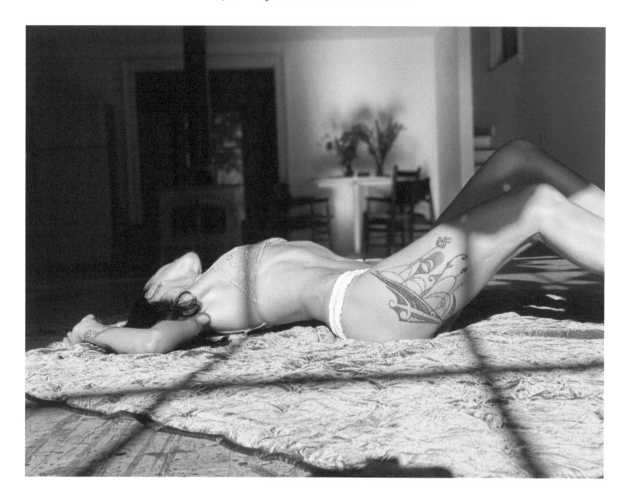

YIELDING

Take me
 her glorious scent filling the air
 her legs parting

Take me
 he understands what this moment means
 the veil dropping
 unprotected, exposed

Take me
 her need bleeding out
 in aching desire

Take me
 the indomitable
 wishing to be dominated

Take me
 her eyes closed
 she desires him
 baring of flesh
 her back arched
 pelvis tipped in clear longing

Take me
 this goddess
 willing to let go of her throne

legs wrapping around the one
she now pulls achingly inside

Take me...
and so he does
exploding pleasure found in her

hair slick...tousled moans

And now taken...he sees her utterly

her physical surrender
fueling her
teaching her
humbling her

for she's intuited since the beginning

all power shatterable
all beauty diminishing
all greatness collapsible
all good fortune lost with the slightest tipping

she, an *indomitable force* shaped
by the *inevitable yielding* to the hands she leads

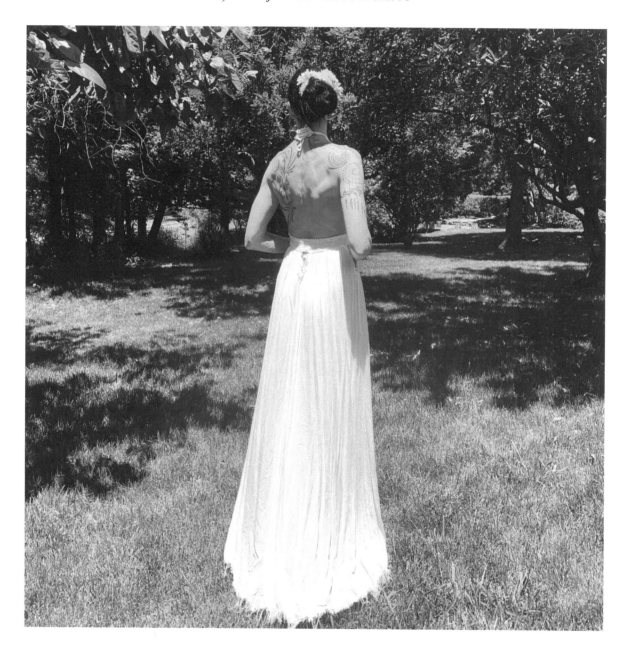

BROKEN ANGEL

I felt her
before I saw her

she
the kind of woman
who entered a place
filling it in a way
few could

and she looked as I imagined
a simple dress
lovely neck exposed
soft tendrils held in place
with flowers already dying in her hair

dying flowers in lifeless waves
 and somehow...still beautifully whole

I never did see her face...
and sometimes, on walks in gardens filled with flowers
alive and dying
I still imagine how she may have looked

it is enough
 I suppose
 a glimpse of beauty
 not fully seen

it is enough
 I suppose
 an angel walking among us

 dying just like you and me

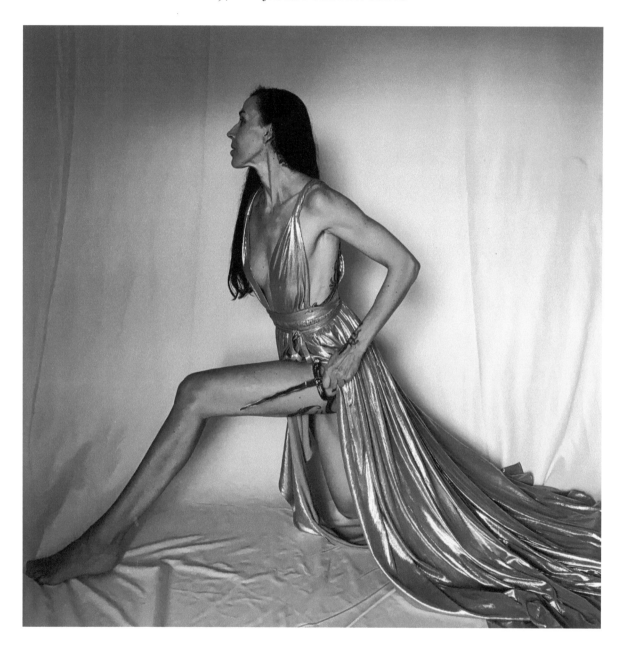

POETIC JUSTICE

How do you handle her?
Long legged beauty, so wild and free

You don't **handle** *someone like her...*
you step back and let her come alive
all the while understanding
that you can't have someone like her

so vibrant
so extraordinary

without its brutal opposite
lying firmly beneath

such a gift finds its origin not only in the simplicity of the sublime
it finds it as well in the bowels of the appalling
with a sting that makes you fall to your knees

No, you don't **handle** *her...*
you rise to her...

an unwillingness to do so
she will leave you remembering
not what drew you to her

you will be left remembering what she drew from you
when you chose not to revere treasure tied to poetic justice...

III

the Light

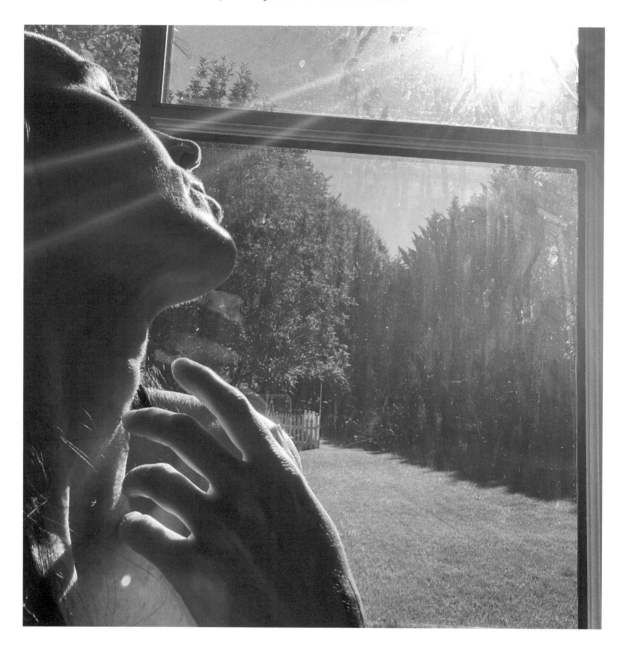

HELD INTIMATELY

It surrounded her

you could tell she felt it too
the way her eyes closed
her head leaning ever slightly
her body still
 quietly responding
 to what held her so completely

and what was so profound
was what she seemed to see
so clearly behind shut eyes

she held it, in virtuous turn
 beautifully
 poetically
with a purity that brought tears to your eyes

and the moment slipped away
as easily as it had arrived...

but not forgotten

I will not forget

Her
a life

a small drop
cradled in immensity

yet
 somehow
 someway

She had discerned the divinity...

 of being held intimately
 of being known personally

within the vast infinity of it all

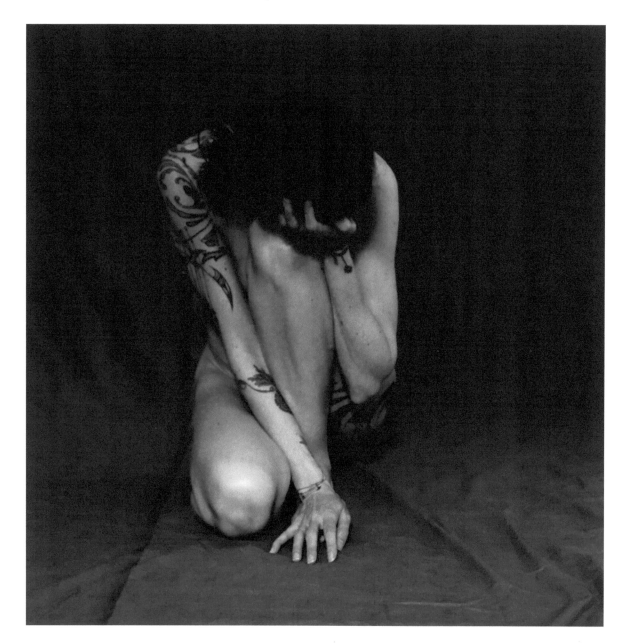

SOUL

she touched its warmth
she felt its light
she so loved its truth

and wishing to protect it
she held it ever so close
her delicate frame guarding
keeping watch...keeping safe
from all that lay beyond

but her soul knew what it was made of
and nudged its way through
wrapping itself on the outside
reflecting gracious light to everyone she knew

for her soul
was never meant for safety
never meant to hide

it was meant
to be seen and heard and known
and loved by life on the outside

it was meant to be her mighty shield
by taking all the blows
meant to be her shimmering beacon
by calling to all that strengthens and grows

so I share you willingly
with all that is out there
but forever I will keep a part of you
the piece I will not share

for part of what others are drawn to
when too close, can make them blind
so I keep it hidden & away
leaving the seekers searching...
for something they will never find

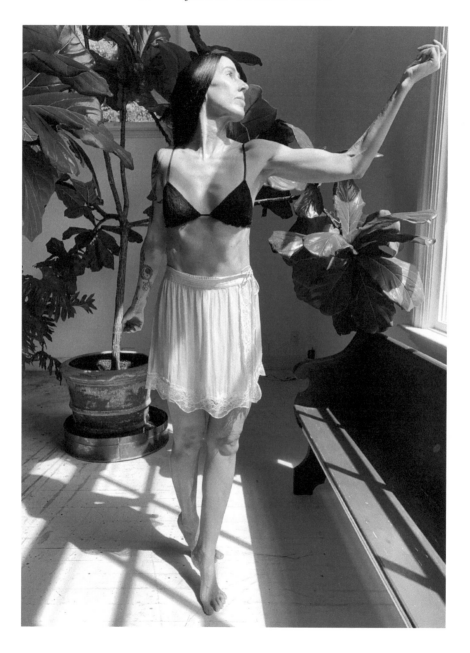

LABYRINTH

She was born for this
 a déjà vu
 a labyrinth they're willing to walk
 to reach the center of her...

move with haste
 her maze always changing
 but you've been here before

she was born for this
 do not hesitate
 the journey will grant you what you seek

for in walking her labyrinth
you've invited her into yours...
and with the merging of the two
the prophesy becomes clear...

She, the *afterglow* of the reflection of *you*

her flame illuminating what you couldn't find
her blaze, a beacon calling to the others

guiding the seekers of her light
back home
to the discovery of their own

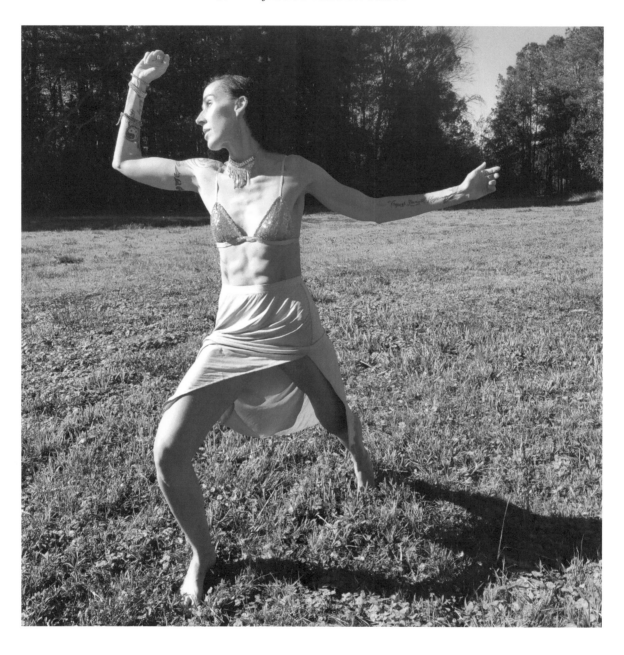

DANCE WITH ME

unsteady

walking the high wire
hair flying, covering her eyes
wind relentless
unforgiving pellets of rain
reminders of what afflicts

unsteady

She wants to fly
let go of me
crescendo born from
a lifetime of quiet forging
the art gasping to be released

unsteady

Don't look down
the wave is coming
it wants to push you up
to showcase what needs to be

unsteady

Trust the way it holds you
you fear the breaking apart

the turbulence building...
fear never leaves quietly

unsteady

It's holding you
 its treasured dance partner...
 dipping, twirling, birthing the art of you
 as you dangle

unsteady

It won't let go
the adoration of you, won't let it
give it what it burns for
a color it's never seen before & won't ever see again

unsteady

Give unto it
and when it must release you
it will let go willingly
your color forever memorized
forever held in its sky
as it searches
for the next undiscovered color
to place beside yours

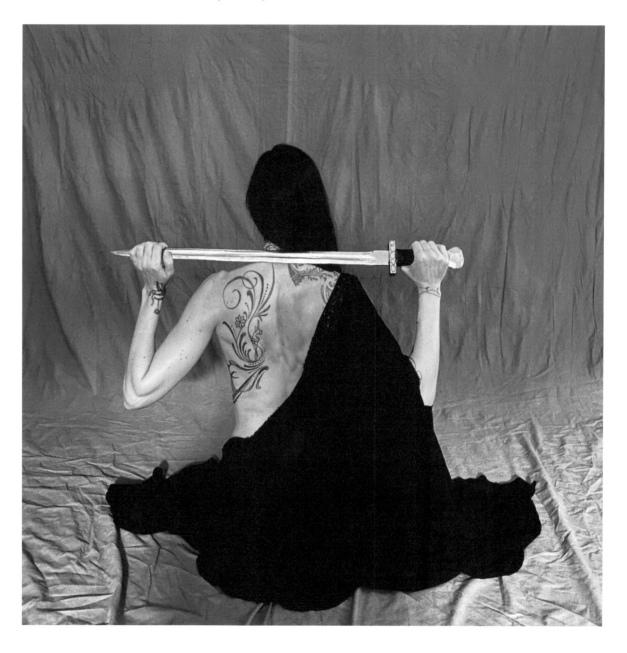

WOMAN

They called her a warrior

Some said
a brazen & daring sage
fighting the call to lead
so that she could freely bleed

but to her
it was something different

stripped bare
blade upon her shoulders
the yoke easy
the burden light

brave and true
focused
intent
on the converging
of what lies within
and what lies out there

for glory
for beauty
 she carries the shards splintered from
 the balancing scale
 her cloak shielding her spirit

willingly slipping from her shoulders
to reveal who she sees herself to be

GLORIOUS
BEAUTIFUL...

WOMAN

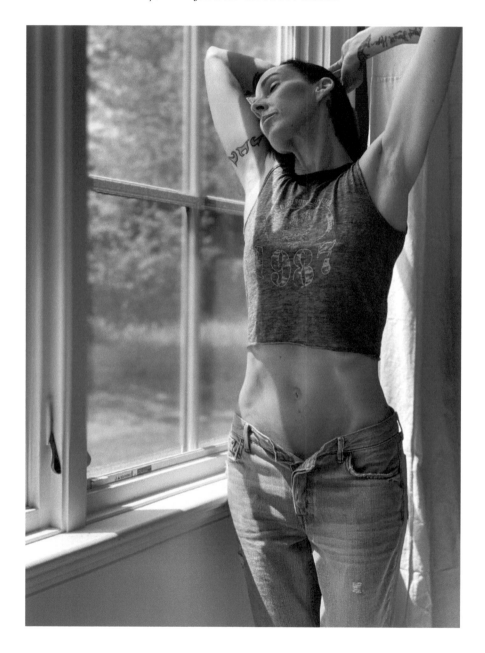

TIMELESS

it left me speechless
the way she didn't even realize
how beautiful she looked in that moment

head back
midriff exposed
arms cast in relaxed angles over her eyes

and what was so amazing
about the trance I found myself in
was what actually kept me
thinking about her long after she'd gone

it was the rise and fall of her ribcage
and the thought that the air she breathed
was the air I was breathing

and I suppose there was a hope
that I had claimed a small part of her

but then I remember her closed eyes

there was no claiming her...

there was only the claiming
of the memory of her

her ribcage rising and falling
like memories do...
 the aging of them
 yielding less accuracy in their recalling...
 but greater understanding

that sometimes the briefest of moments
leave imprints so great
they take a lifetime to grasp the beauty of them...

 and so it seems
 true beauty
 is timeless after all...

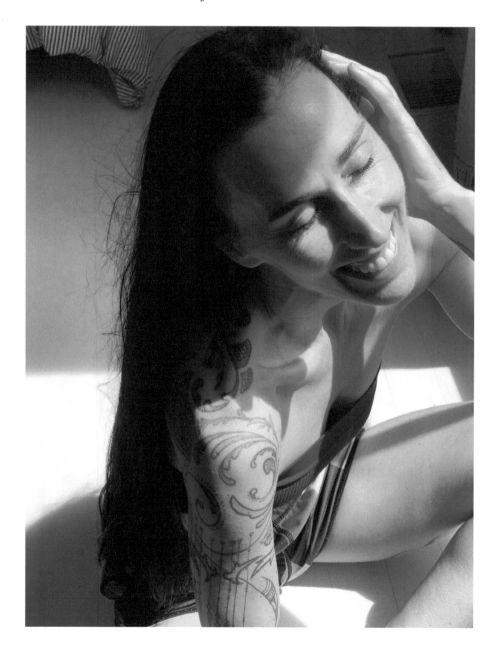

SET FREE

Her hair
long & loose
head tilted back and up
smiling & gazing
at that sky she is always reaching for

the sun playing attentive lover
with her raven, silk tresses
shimmering on the face
that seems to always be turned
toward what makes her feel whole

the window framing her
a living photo
of a spirit set free

a glimpse of her
unguarded & pure
instinctive & willing

a girl with a steady heart
taking it for an unsteady ride
in the wild & free

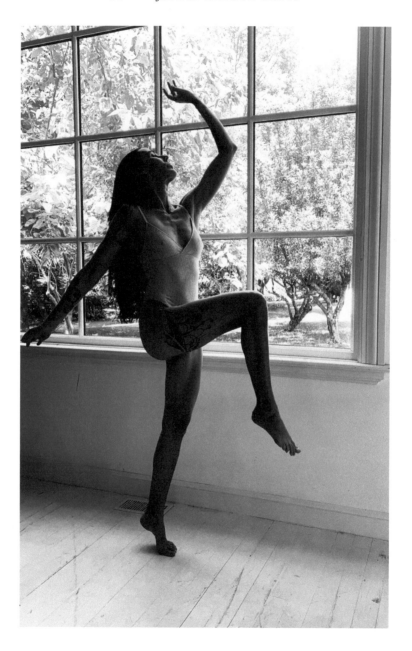

CONSUMED

"Shhh...quiet...I'm watching her..."

'do you really think she
 doesn't know you are?'

"Of course she doesn't...
she's lost in her own world."

 'just because she's
 lost in hers
 doesn't mean
 she's not aware
 that she's consumed yours...'

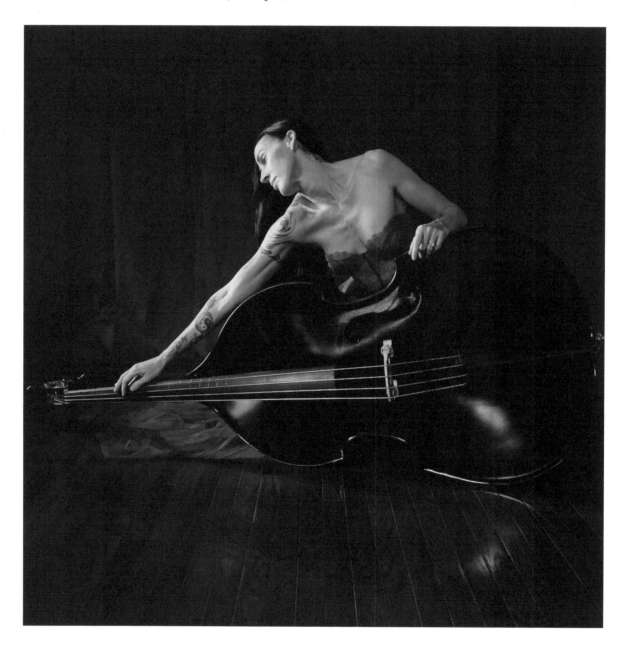

MASTERPIECE

Pluck me
I, your string
let me feel your fingers
pull at me relentlessly

focused
insistent
driven to play

I know you ache
wishing to hear me hum
your hand on my slender neck
fingers over warm pulsing flesh
tuning me to the sound of need

lean the curve of me
into the hardness of you

sway with the rhythm you pluck from me
the music emanating off my skin

smooth
firm
flexed
responding to you
you're changing the sound of me
shaping what you wish to hear with your hands

I am yours...
pluck me
fervently
drawing from me
the music you alone compose

your stringed muse
extract the glorious song
vibrating
stimulating
erotic
 complete

finish your symphony
inside of me...
us shaking the air around

I, your string now fully plucked
I, your masterpiece finally found

Thank you...

to all of you who have touched my life and never even knew you had

to all of you who had the courage to share your art with the world..it gave me the courage to share mine

to my father who showed me how to be grateful

to my mother who showed me how to be strong

to my stepfather whose gentle spirit filled the void

to my twin sister who never let go

to my older sister who always believed I could

to my brother who came home

to my sons who make my soul exquisitely spin

to my husband who witnesses the dark, the gray, the light and gives me the space to come alive

and to God who gifted me the opportunity to live this extraordinary life

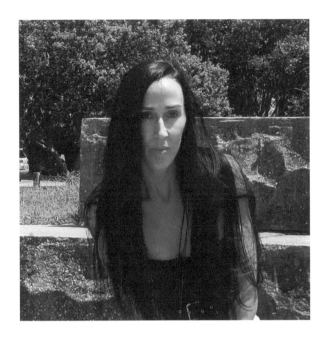

Born in Montana, Janna Watson Smits
currently lives in Virginia with her
family. She loves dancing and dresses
and laughing until she cries; she loves
the color blue, country music and good
strong words that mean something.

Her superpower...lighting up a room.

*Visit Janna on Instagram @poetry_by_jws

*Images by JWS/RLS Photo

CPSIA information can be obtained
at www.ICGtesting.com
Printed in the USA
BVHW020512251120
593914BV00001B/1